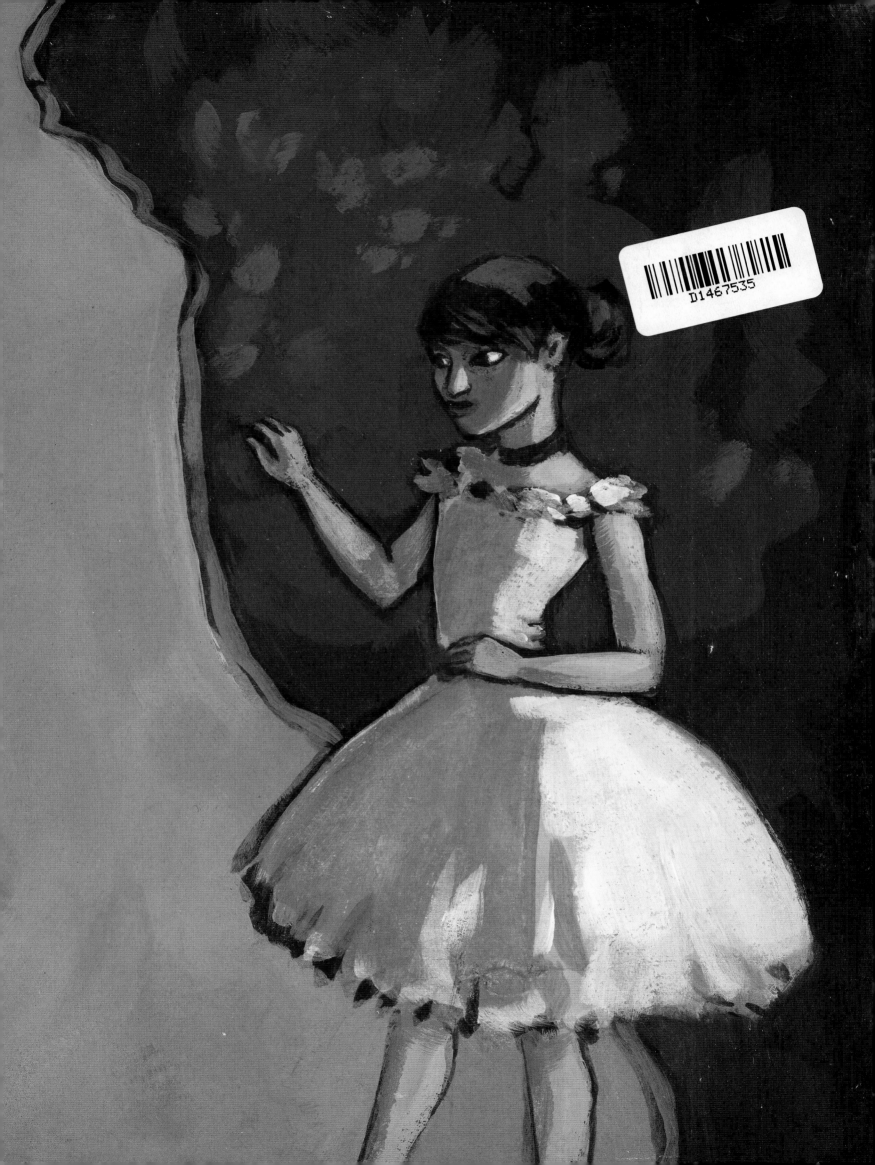

For Laura
H. K.

© for the original French edition: L'Élan vert, Paris, 2009
Original French title: Mystères en coulisse.

© for the English edition: Prestel Verlag, Munich · London · New York, 2011

Photo credit: Edgar Degas, The Rehearsal of the Ballet Onstage, 1874
© Metropolitan Museum of Art, New York / bpk
The Deutsche Nationalbibliothek lists this publication
in the Deutsche Nationalbibliografie; detailed bibliographic information
is available at http://dnb.d-nb.de.

Prestel Verlag, Munich
A member of Random House GmbH
www.prestel.com

English translation by Cynthia Hall, Stephanskirchen

Editing: Brad Finger
Layout: Meike Sellier, Eching
Production: Nele Krüger
Printing and binding: Tlačiarne BB, spol. s.r.o.
Printed in Slovakia.

ISBN 978-3-7913-7081-1

Little Ballerina

Inspired by a painting by Edgar Degas

Text by Hélène Kérillis
Illustrations by Lucie Albon

PRESTEL
Munich · London · New York

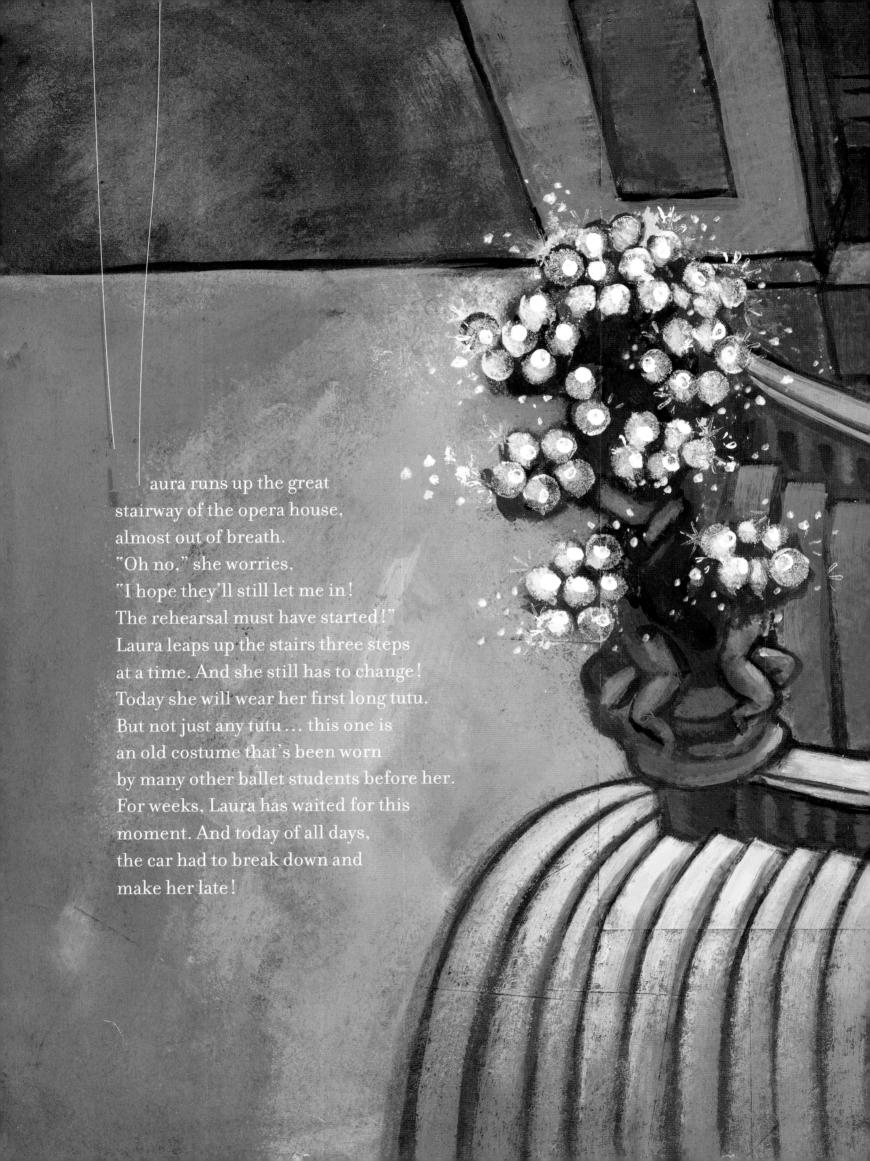

aura runs up the great
stairway of the opera house,
almost out of breath.
"Oh no," she worries,
"I hope they'll still let me in!
The rehearsal must have started!"
Laura leaps up the stairs three steps
at a time. And she still has to change!
Today she will wear her first long tutu.
But not just any tutu … this one is
an old costume that's been worn
by many other ballet students before her.
For weeks, Laura has waited for this
moment. And today of all days,
the car had to break down and
make her late!

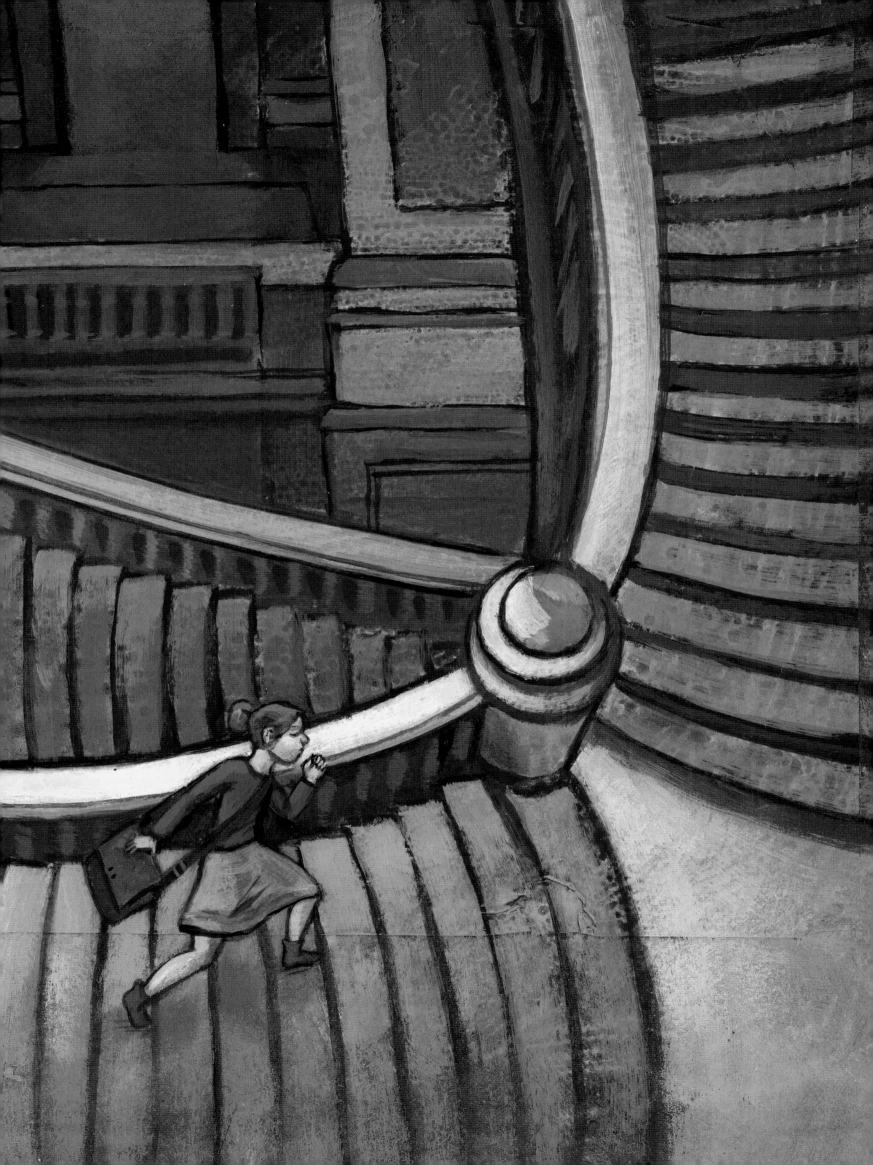

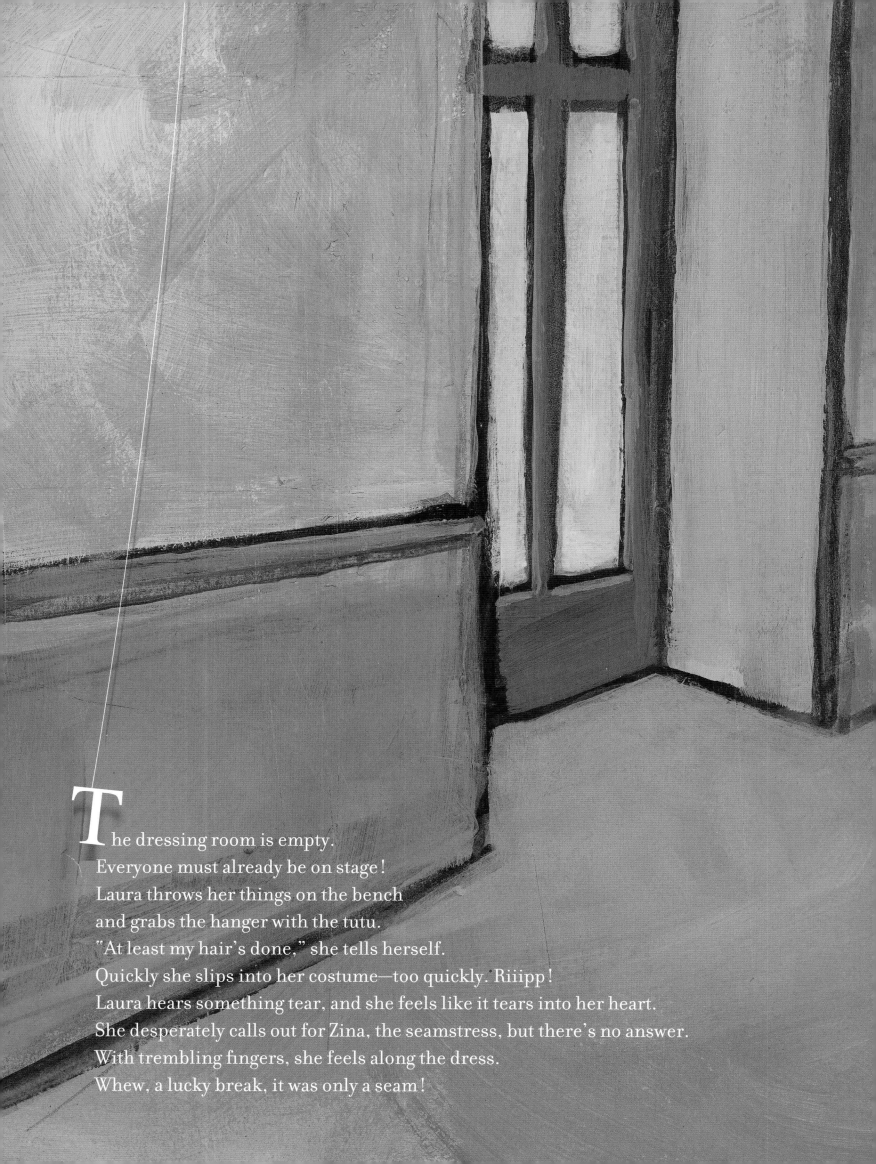

The dressing room is empty.
Everyone must already be on stage!
Laura throws her things on the bench
and grabs the hanger with the tutu.
"At least my hair's done," she tells herself.
Quickly she slips into her costume—too quickly. Riiipp!
Laura hears something tear, and she feels like it tears into her heart.
She desperately calls out for Zina, the seamstress, but there's no answer.
With trembling fingers, she feels along the dress.
Whew, a lucky break, it was only a seam!

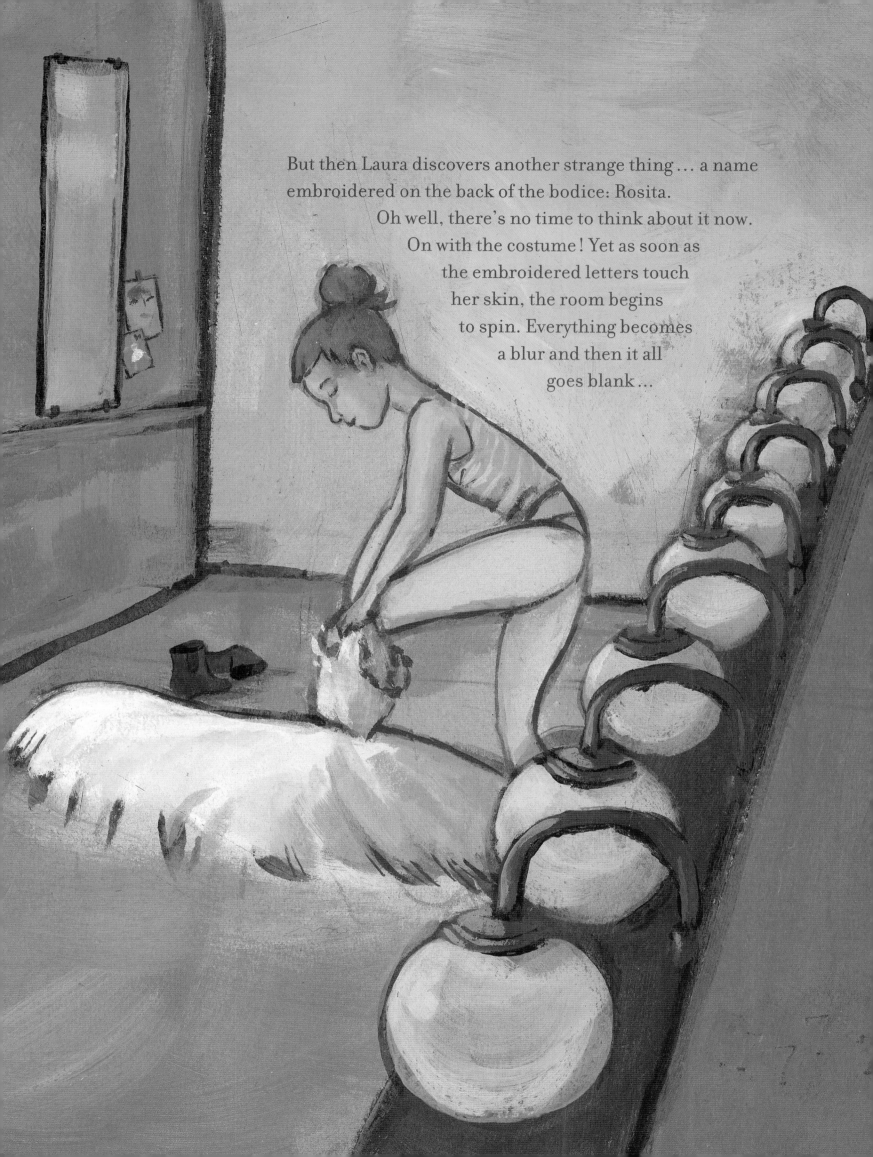

But then Laura discovers another strange thing ... a name
embroidered on the back of the bodice: Rosita.
Oh well, there's no time to think about it now.
On with the costume! Yet as soon as
the embroidered letters touch
her skin, the room begins
to spin. Everything becomes
a blur and then it all
goes blank ...

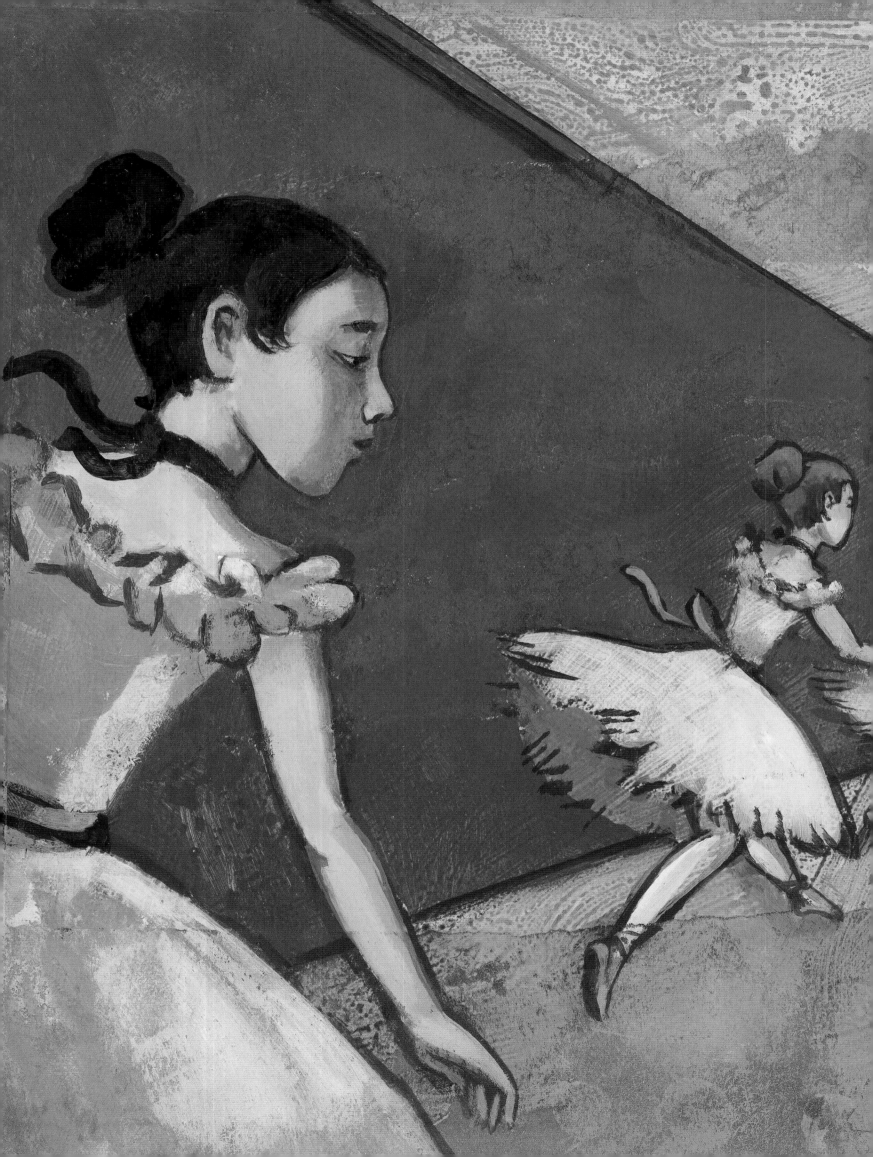

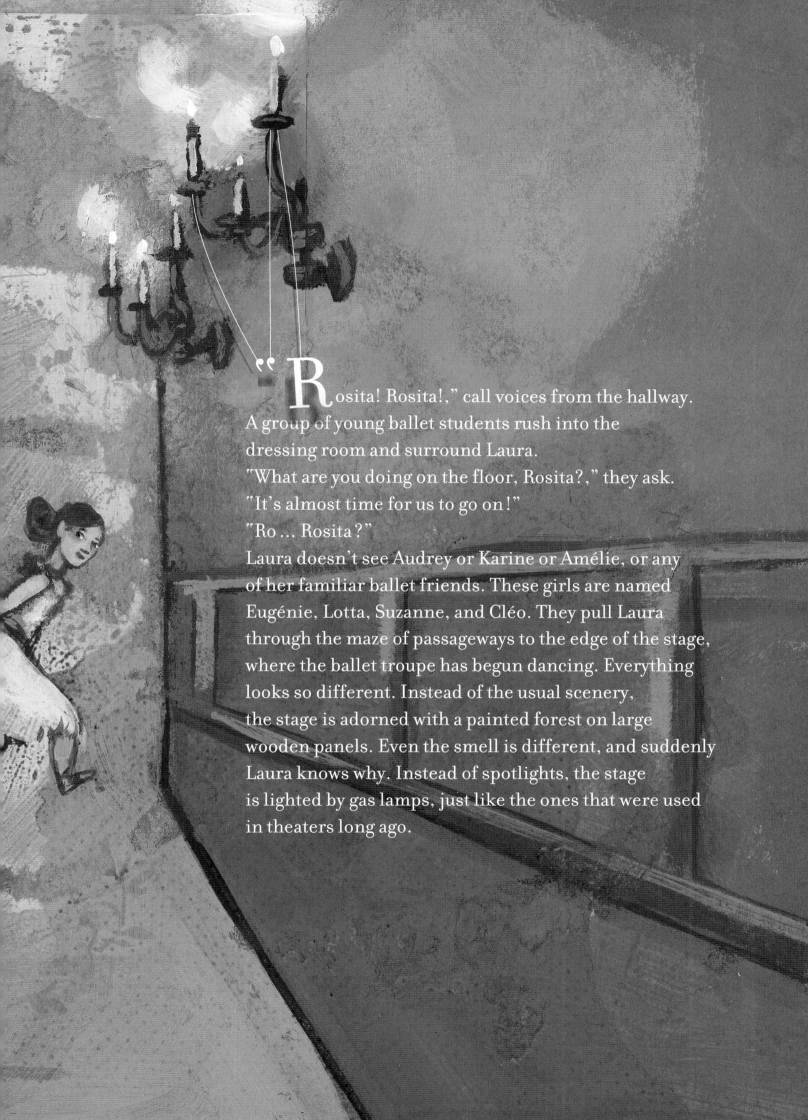

"Rosita! Rosita!," call voices from the hallway.
A group of young ballet students rush into the
dressing room and surround Laura.
"What are you doing on the floor, Rosita?," they ask.
"It's almost time for us to go on!"
"Ro … Rosita?"
Laura doesn't see Audrey or Karine or Amélie, or any
of her familiar ballet friends. These girls are named
Eugénie, Lotta, Suzanne, and Cléo. They pull Laura
through the maze of passageways to the edge of the stage,
where the ballet troupe has begun dancing. Everything
looks so different. Instead of the usual scenery,
the stage is adorned with a painted forest on large
wooden panels. Even the smell is different, and suddenly
Laura knows why. Instead of spotlights, the stage
is lighted by gas lamps, just like the ones that were used
in theaters long ago.

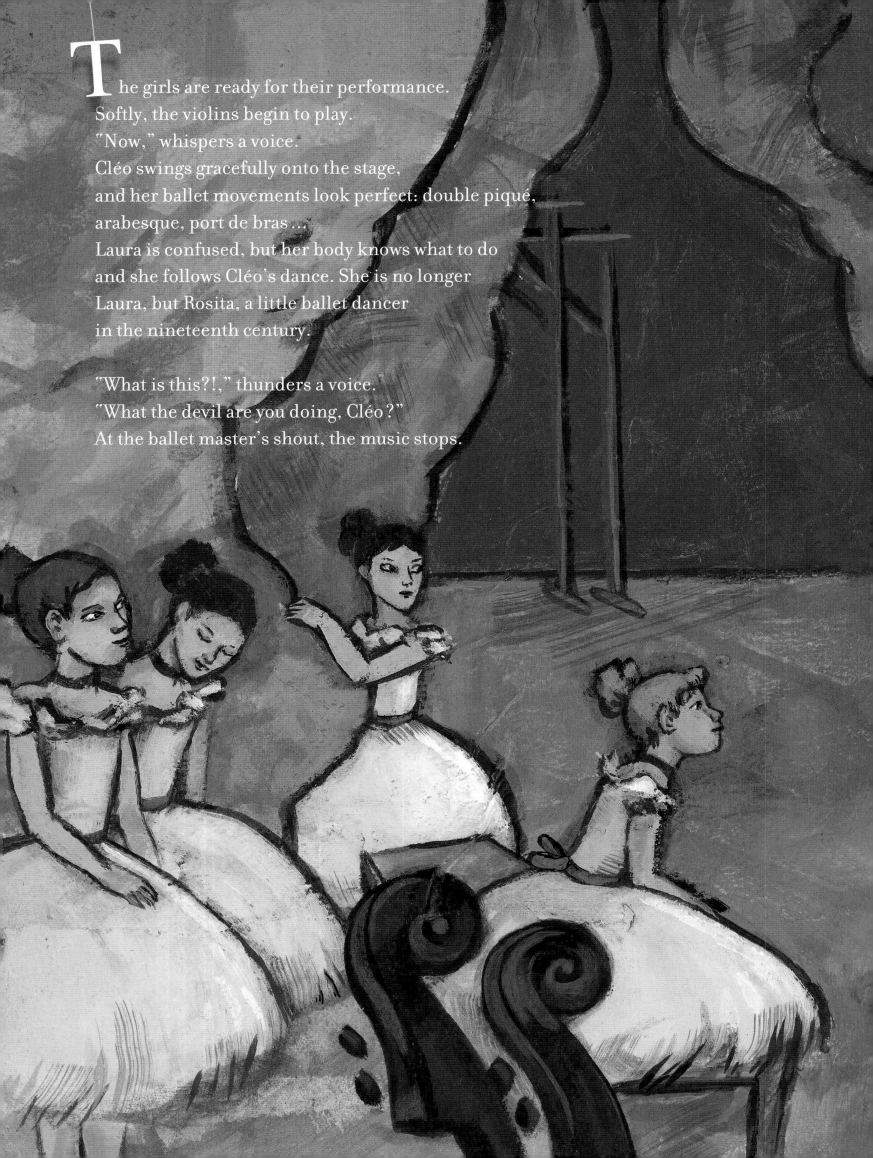

The girls are ready for their performance.
Softly, the violins begin to play.
"Now," whispers a voice.
Cléo swings gracefully onto the stage,
and her ballet movements look perfect: double piqué,
arabesque, port de bras…
Laura is confused, but her body knows what to do
and she follows Cléo's dance. She is no longer
Laura, but Rosita, a little ballet dancer
in the nineteenth century.

"What is this?!," thunders a voice.
"What the devil are you doing, Cléo?"
At the ballet master's shout, the music stops.

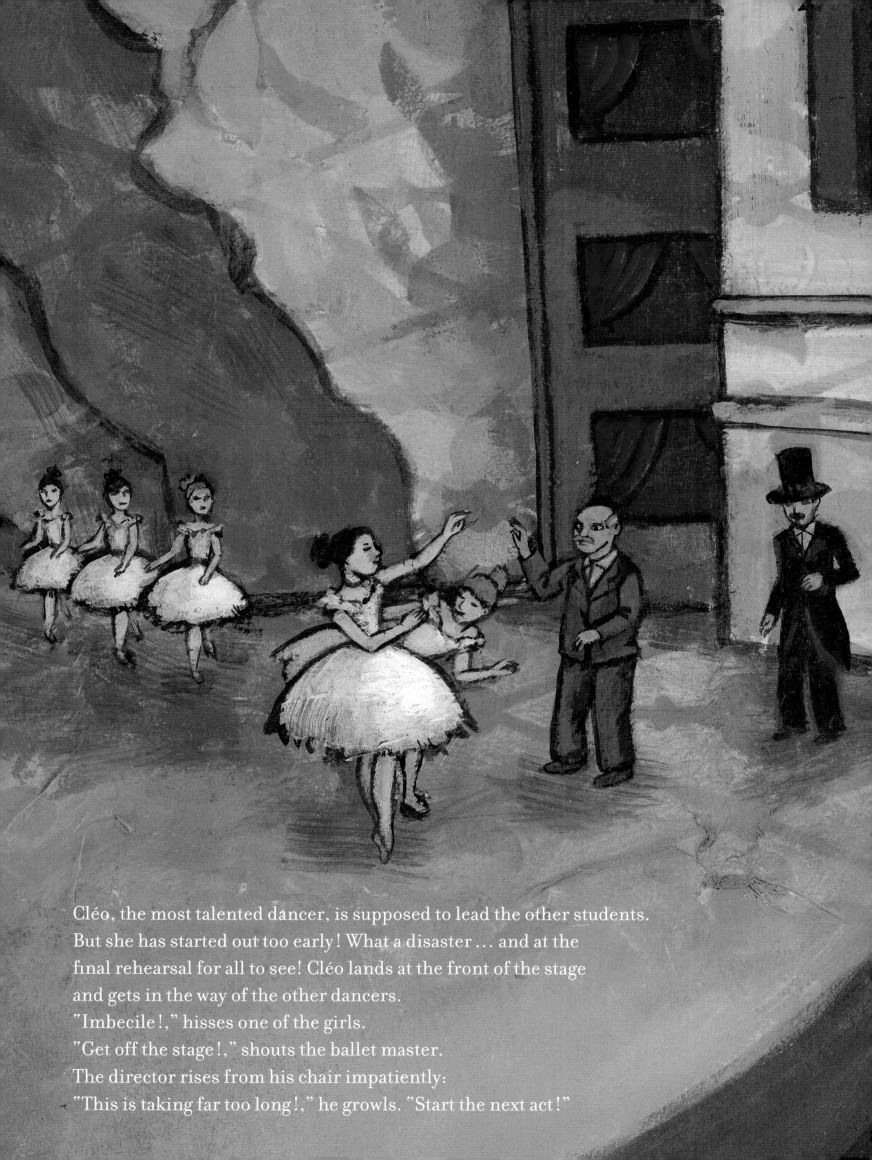

Cléo, the most talented dancer, is supposed to lead the other students.
But she has started out too early! What a disaster... and at the
final rehearsal for all to see! Cléo lands at the front of the stage
and gets in the way of the other dancers.
"Imbecile!," hisses one of the girls.
"Get off the stage!," shouts the ballet master.
The director rises from his chair impatiently:
"This is taking far too long!," he growls. "Start the next act!"

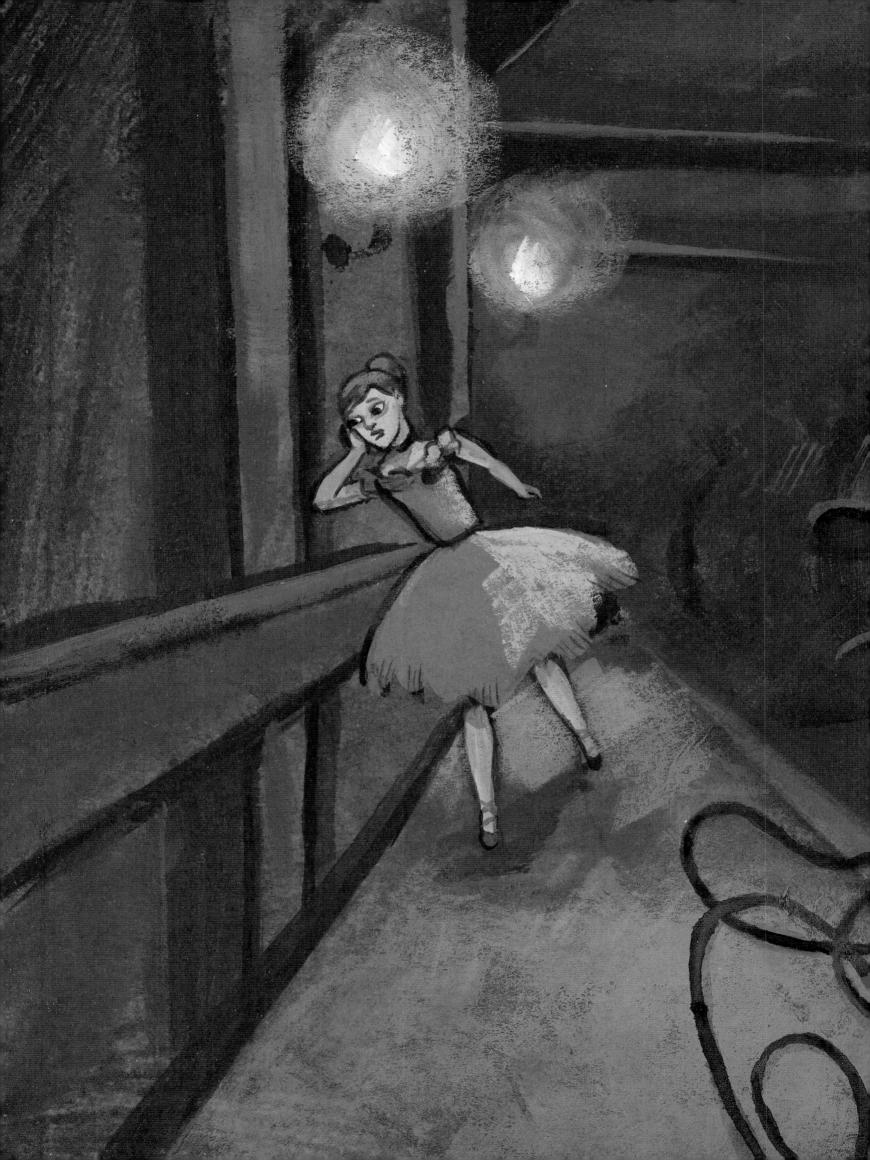

Cléo runs off
in despair, her cheeks
red with shame. But Laura
can only return to the wings
and join the other students.
Fear is in the air as the girls
talk about the incident.
After all, it was one of them
who gave Cléo the wrong cue
and caused her mistake!
"Do you think they'll
get rid of our part?"
"They will for sure
if we don't find Cléo!"
The girls set out to retrieve
their fellow student.
Laura searches through
the painted forest and
whispers Cléo's name.
She feels her way carefully
through the semi-darkness,
pushes a curtain aside, and
slips between the painted
scenes. Suddenly she stops:
there's Cléo!

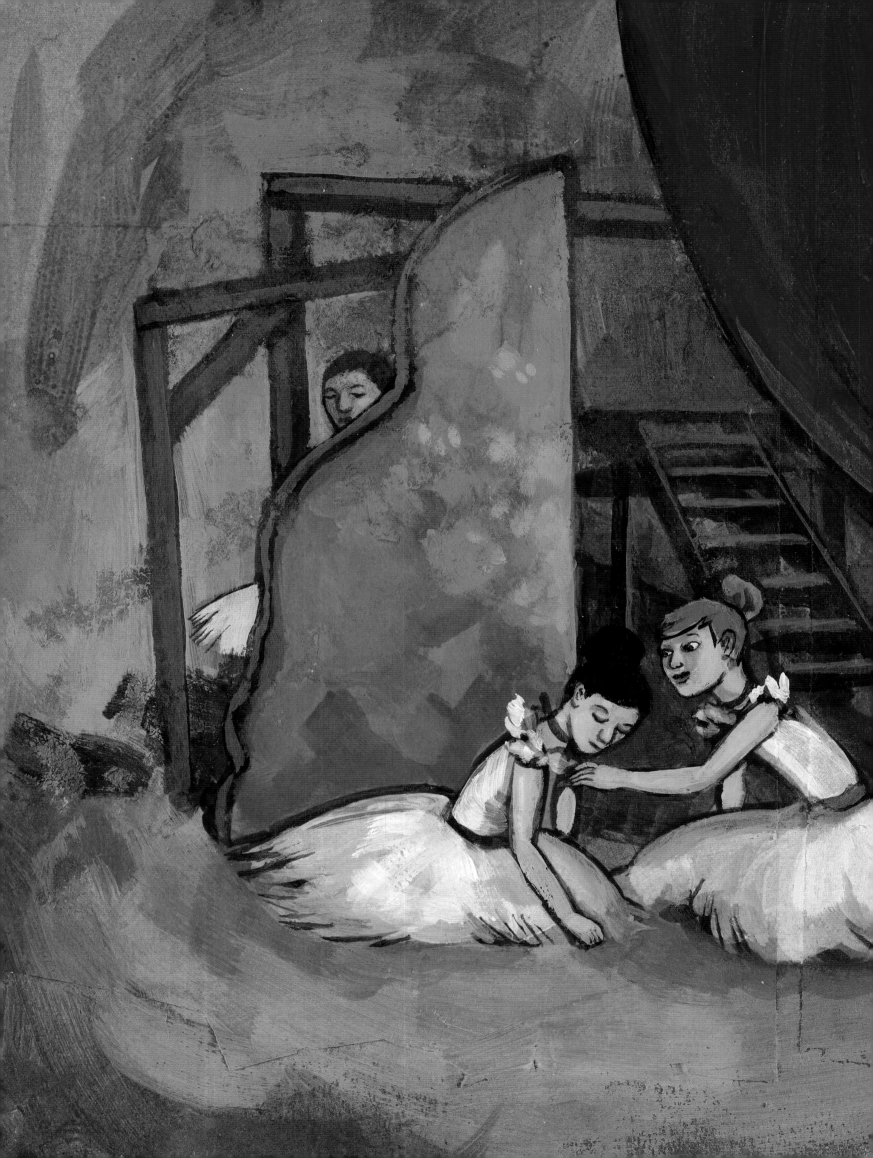

Cléo is sobbing, huddled against a panel
of scenery. "I ... I can't anymore ...," she cries.
Laura comforts the little dancer. But suddenly she lifts
her head. There, in the shadows, on the other side
of the panel ... someone is spying on them!
Laura can see only the edge of a tutu.
"I can't dance anymore," Cléo whimpers.
But now the hidden girl is pushing against the panel.
It's about to fall on Cléo! Laura jumps up and manages
to grab hold of an arm. She tries to grasp the tutu as well,
but it slips through her fingers. The girl is gone!
But there's something shiny on the floor.
Laura bends down to pick it up.

Meanwhile Cléo has torn off the silk ribbon
that all ballet dancers wear around their necks.
Laura sits down beside her and puts her arm
around her waist:
"I've been looking for you, Cléo!," she says.
"Come on, it's almost time to go on again!"
"I'm not going ...," Cléo weeps. "I ... I give up!"

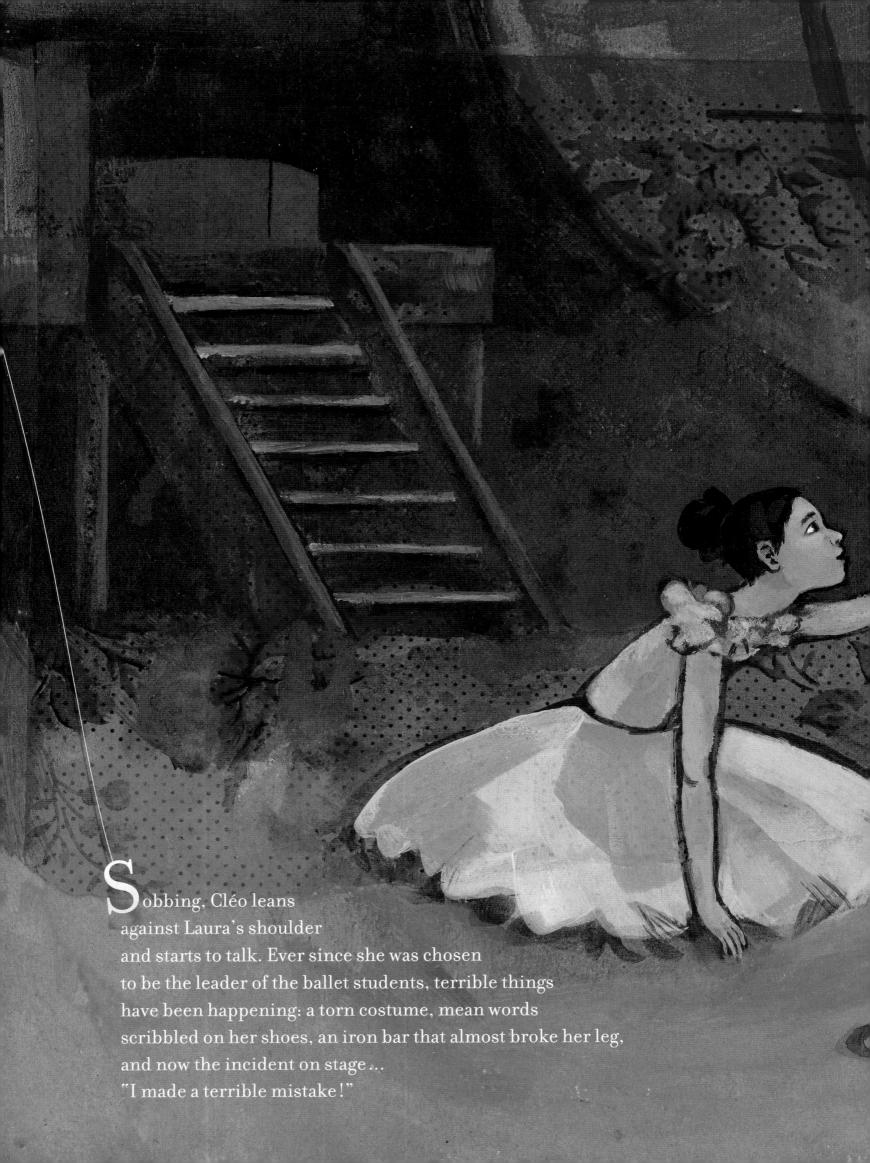

Sobbing, Cléo leans
against Laura's shoulder
and starts to talk. Ever since she was chosen
to be the leader of the ballet students, terrible things
have been happening: a torn costume, mean words
scribbled on her shoes, an iron bar that almost broke her leg,
and now the incident on stage ...
"I made a terrible mistake!"

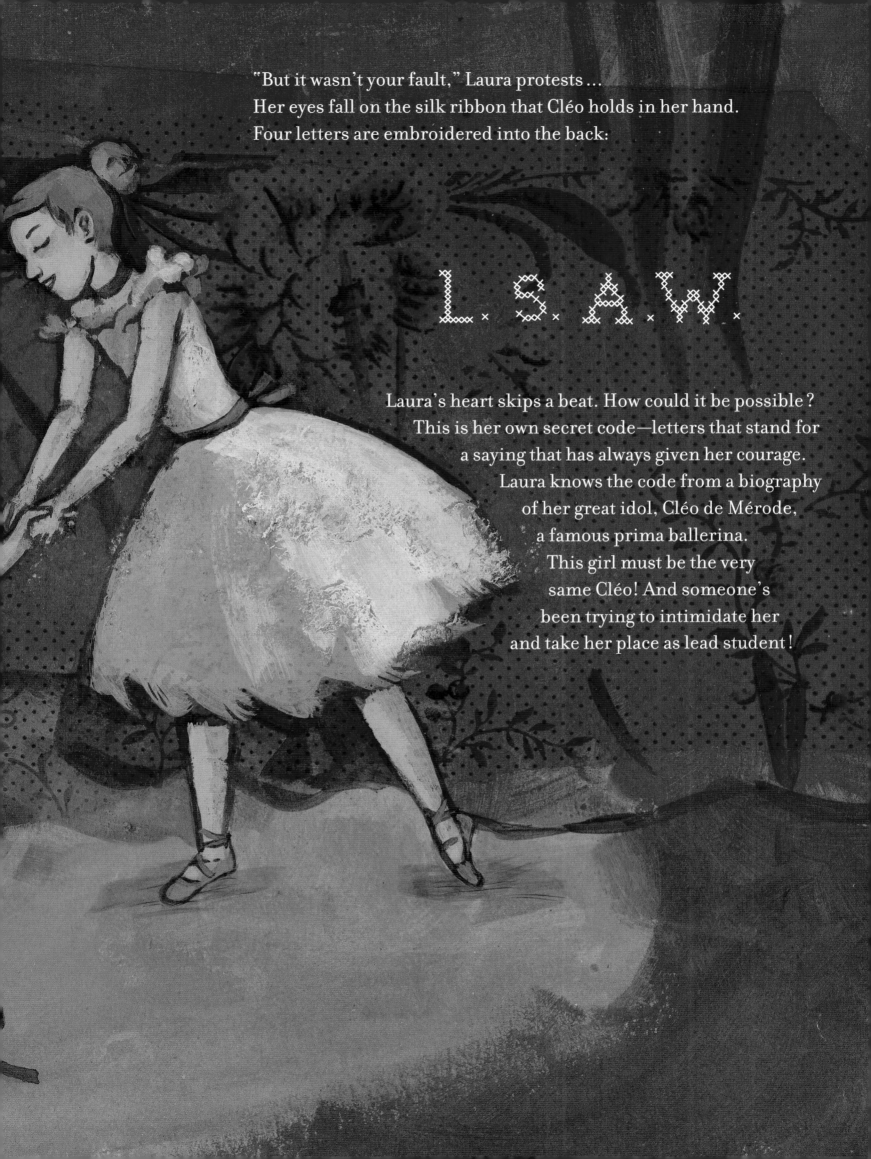

"But it wasn't your fault," Laura protests …
Her eyes fall on the silk ribbon that Cléo holds in her hand.
Four letters are embroidered into the back:

L.S.A.W.

Laura's heart skips a beat. How could it be possible?
This is her own secret code—letters that stand for
a saying that has always given her courage.
Laura knows the code from a biography
of her great idol, Cléo de Mérode,
a famous prima ballerina.
This girl must be the very
same Cléo! And someone's
been trying to intimidate her
and take her place as lead student!

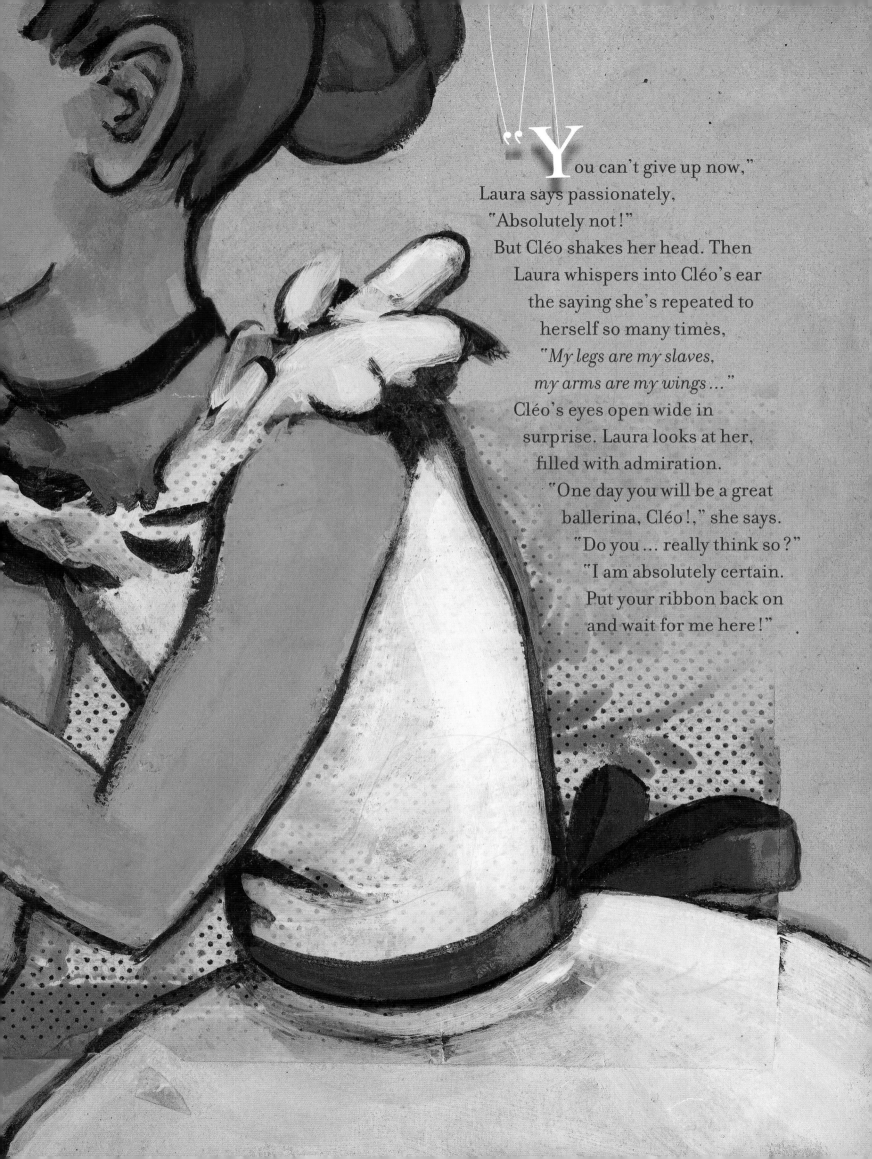

"You can't give up now,"
Laura says passionately,
"Absolutely not!"
But Cléo shakes her head. Then
Laura whispers into Cléo's ear
the saying she's repeated to
herself so many times,
"My legs are my slaves,
my arms are my wings…"
Cléo's eyes open wide in
surprise. Laura looks at her,
filled with admiration.
"One day you will be a great
ballerina, Cléo!," she says.
"Do you… really think so?"
"I am absolutely certain.
Put your ribbon back on
and wait for me here!"

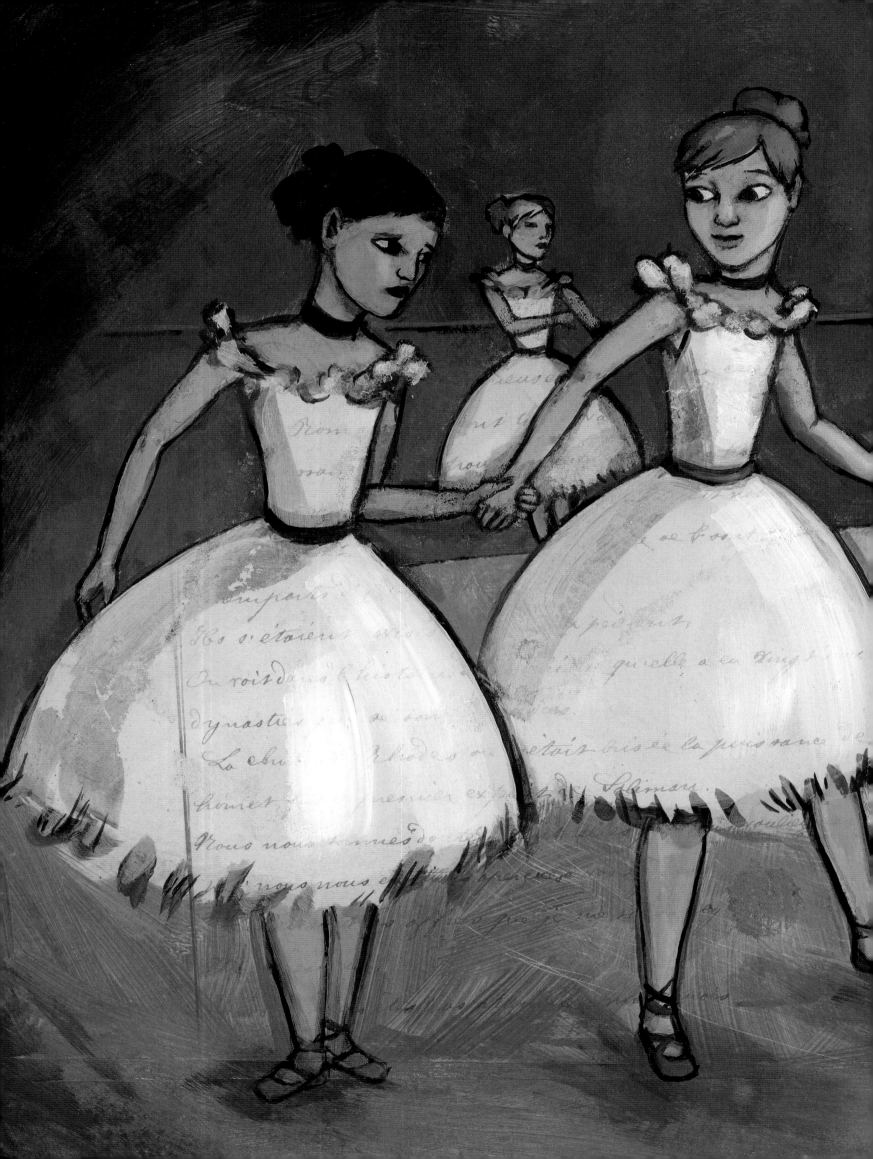

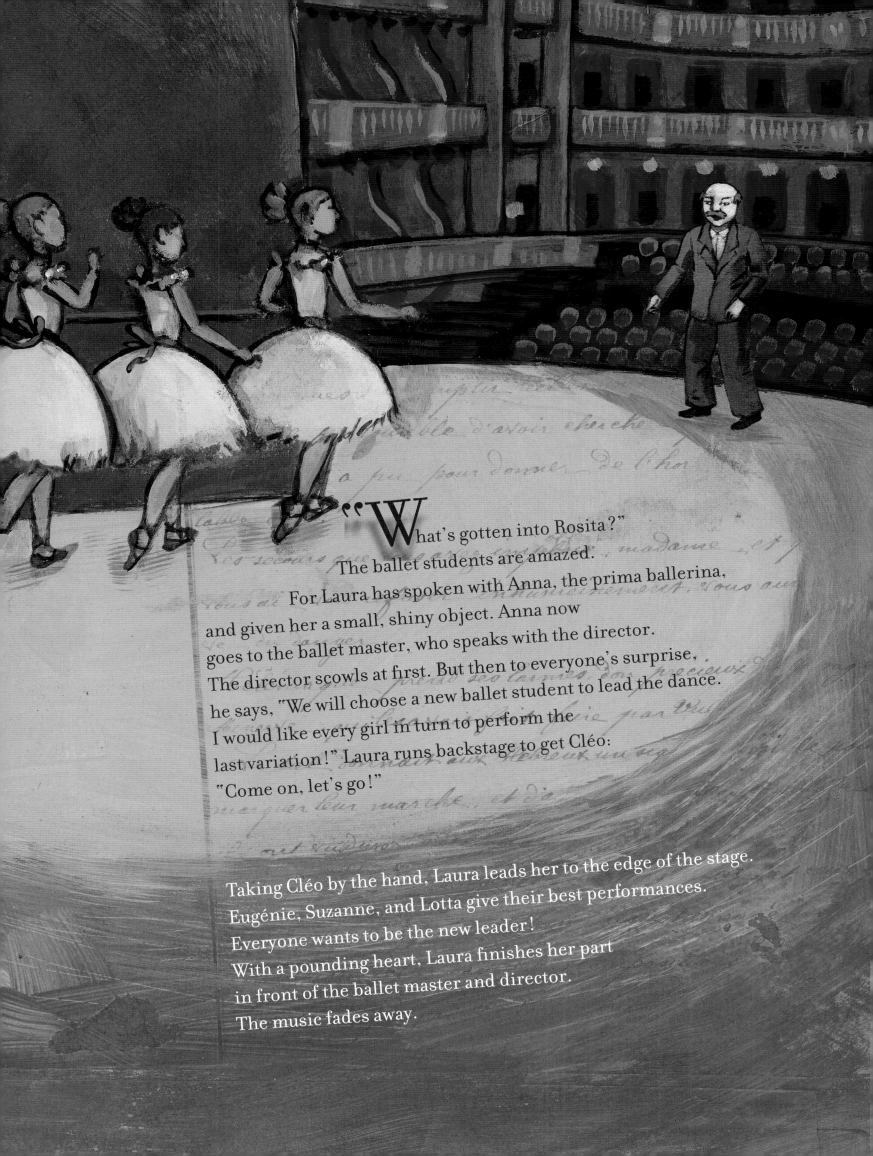

"What's gotten into Rosita?"

The ballet students are amazed.

For Laura has spoken with Anna, the prima ballerina, and given her a small, shiny object. Anna now goes to the ballet master, who speaks with the director. The director scowls at first. But then to everyone's surprise, he says, "We will choose a new ballet student to lead the dance. I would like every girl in turn to perform the last variation!" Laura runs backstage to get Cléo: "Come on, let's go!"

Taking Cléo by the hand, Laura leads her to the edge of the stage.
Eugénie, Suzanne, and Lotta give their best performances.
Everyone wants to be the new leader!
With a pounding heart, Laura finishes her part
in front of the ballet master and director.
The music fades away.

Everyone looks toward the wings: now it's Cléo's turn.
Does she have the courage? The silence is tense and deafening.
Finally a tutu appears, and Cléo steps onto the stage.
As the music begins to play, Laura whispers to herself,
"Her legs are her slaves, her arms are her wings."
And so they are!
Cléo dances as if transformed, almost floating above the stage.
She dances as if she has grown wings.

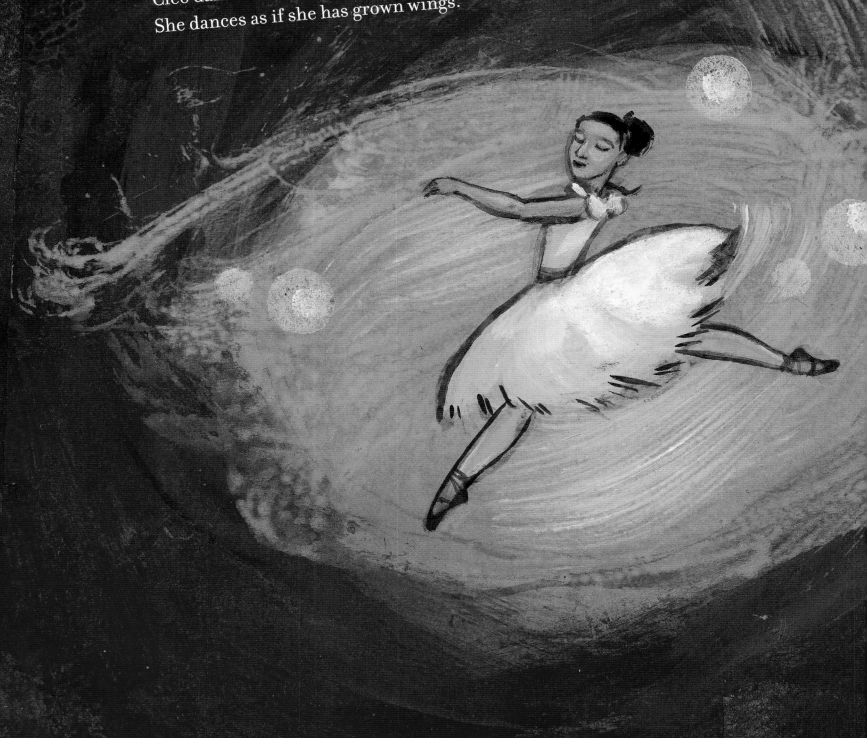

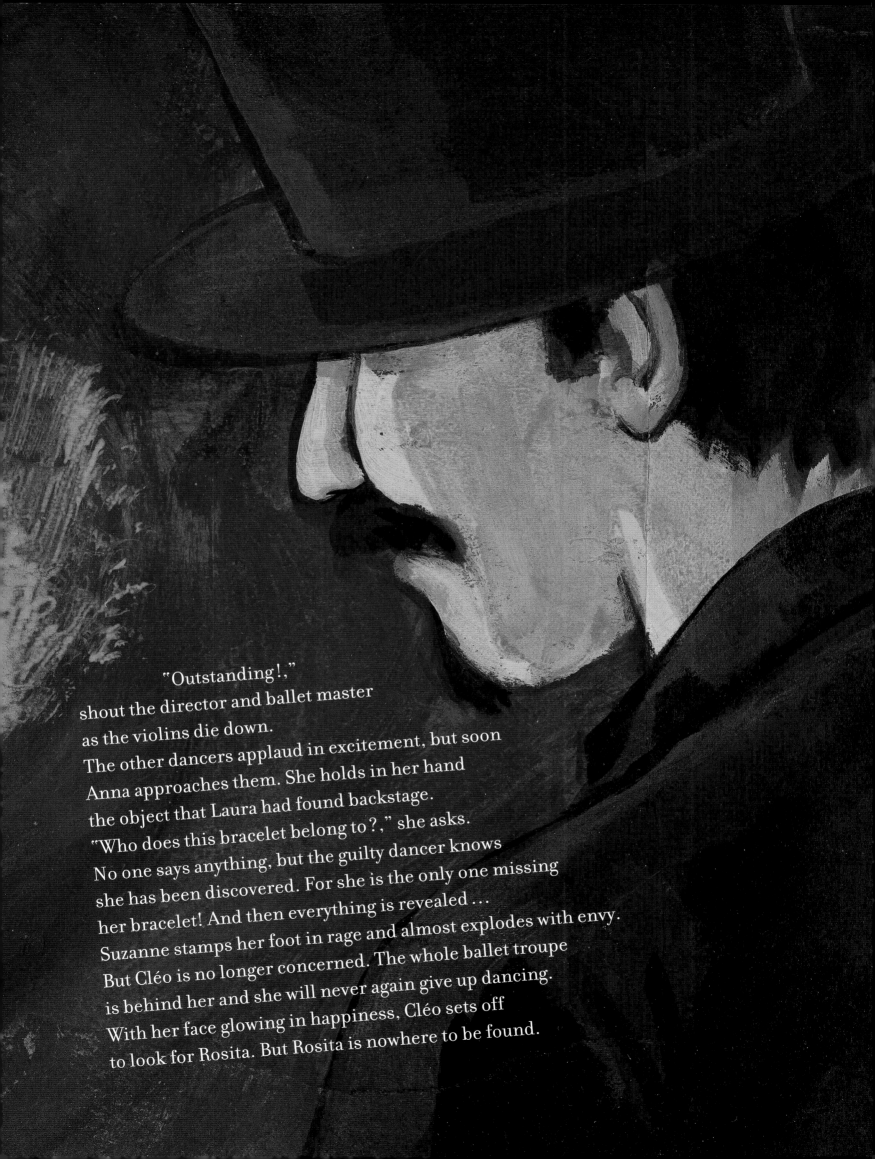

"Outstanding!,"
shout the director and ballet master
as the violins die down.
The other dancers applaud in excitement, but soon
Anna approaches them. She holds in her hand
the object that Laura had found backstage.
"Who does this bracelet belong to?," she asks.
No one says anything, but the guilty dancer knows
she has been discovered. For she is the only one missing
her bracelet! And then everything is revealed …
Suzanne stamps her foot in rage and almost explodes with envy.
But Cléo is no longer concerned. The whole ballet troupe
is behind her and she will never again give up dancing.
With her face glowing in happiness, Cléo sets off
to look for Rosita. But Rosita is nowhere to be found.

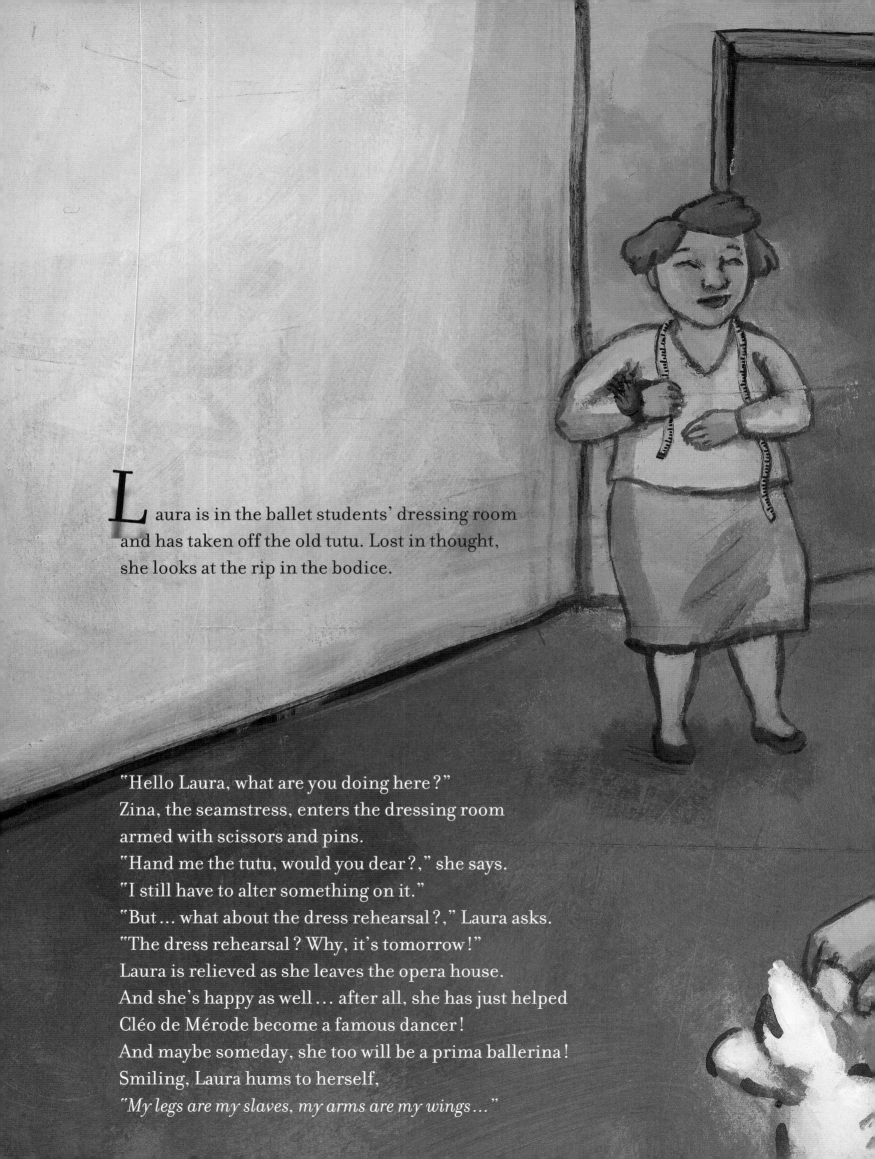

L aura is in the ballet students' dressing room
and has taken off the old tutu. Lost in thought,
she looks at the rip in the bodice.

"Hello Laura, what are you doing here?"
Zina, the seamstress, enters the dressing room
armed with scissors and pins.
"Hand me the tutu, would you dear?," she says.
"I still have to alter something on it."
"But… what about the dress rehearsal?," Laura asks.
"The dress rehearsal? Why, it's tomorrow!"
Laura is relieved as she leaves the opera house.
And she's happy as well… after all, she has just helped
Cléo de Mérode become a famous dancer!
And maybe someday, she too will be a prima ballerina!
Smiling, Laura hums to herself,
"My legs are my slaves, my arms are my wings…"

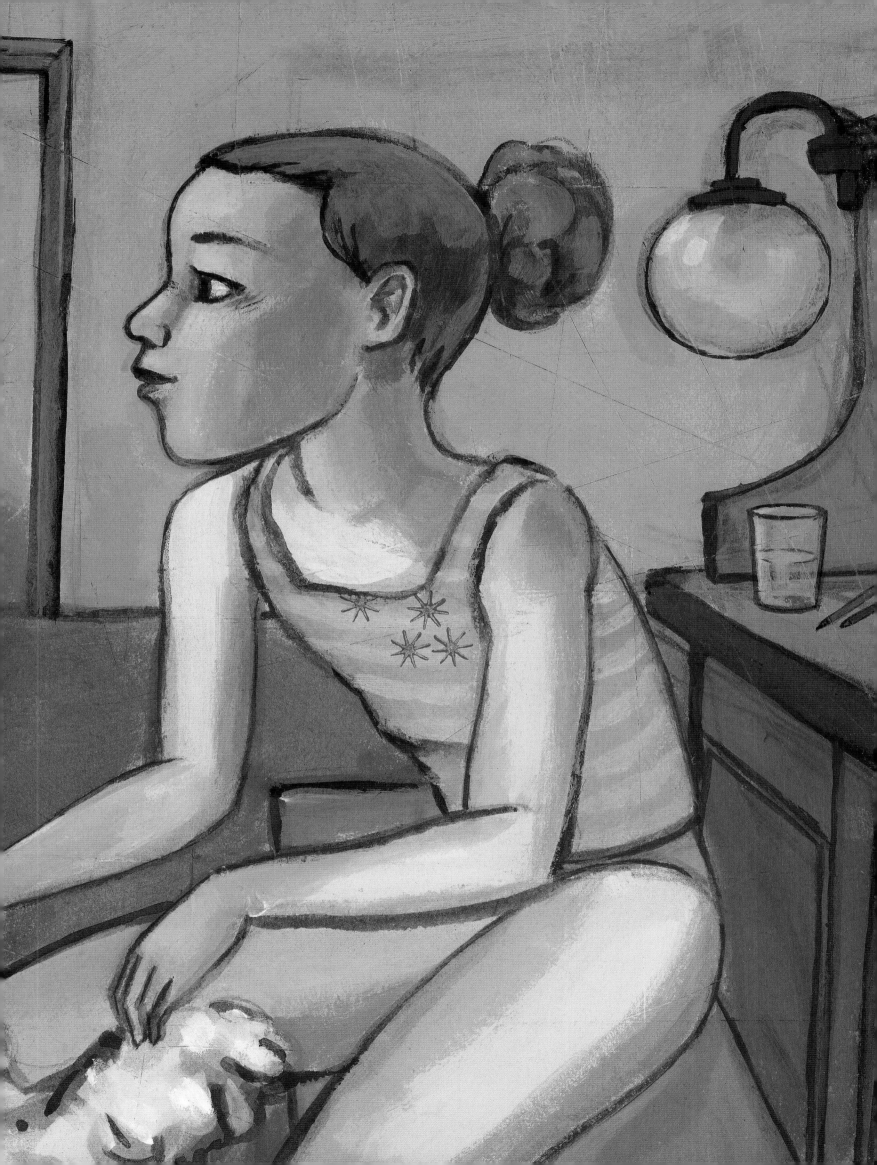

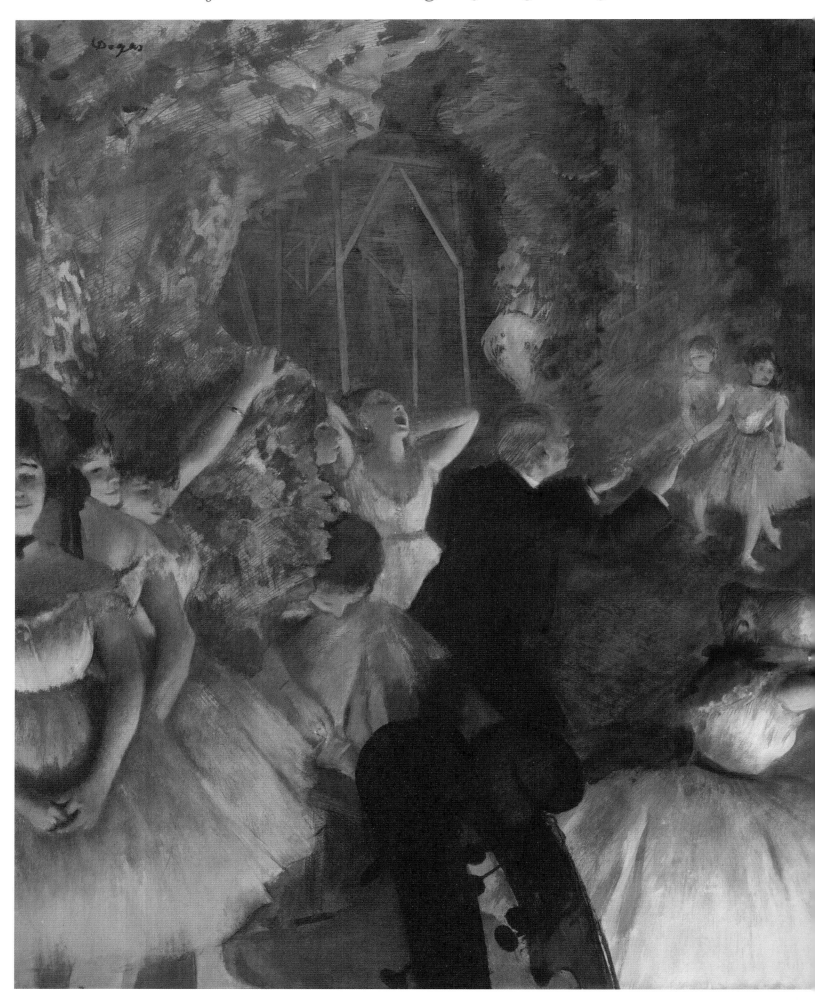

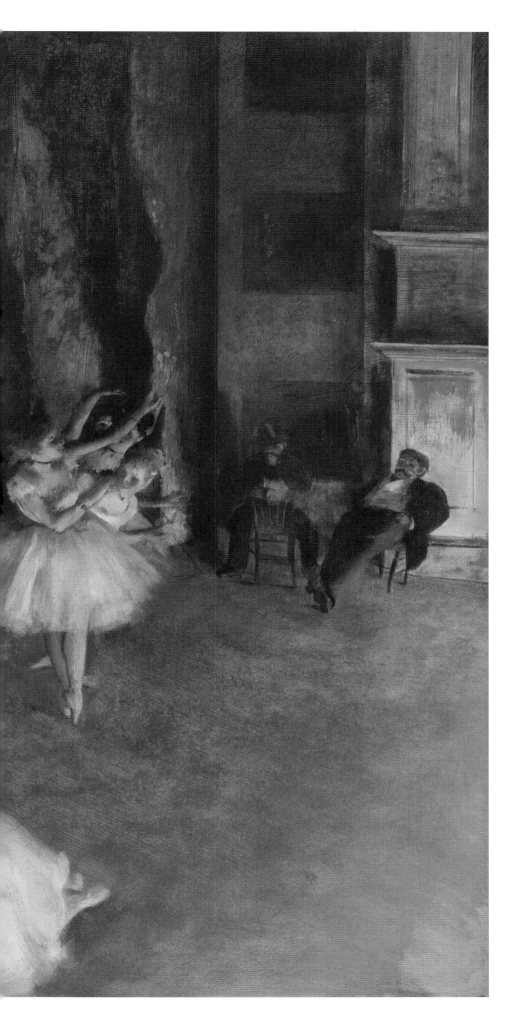

Oil on canvas
55 x 73 cm.
1874
The Metropolitan Museum of Art,
New York

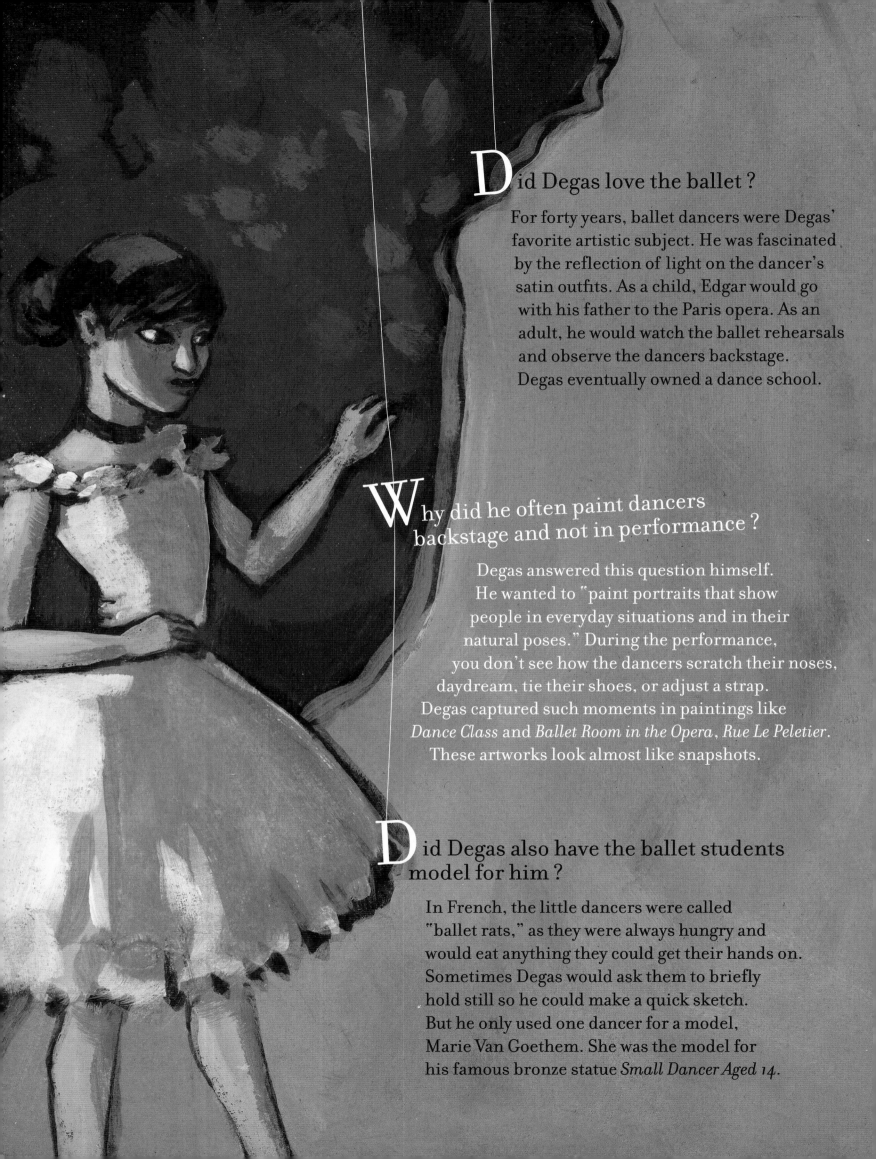

Did Degas love the ballet?

For forty years, ballet dancers were Degas' favorite artistic subject. He was fascinated by the reflection of light on the dancer's satin outfits. As a child, Edgar would go with his father to the Paris opera. As an adult, he would watch the ballet rehearsals and observe the dancers backstage. Degas eventually owned a dance school.

Why did he often paint dancers backstage and not in performance?

Degas answered this question himself. He wanted to "paint portraits that show people in everyday situations and in their natural poses." During the performance, you don't see how the dancers scratch their noses, daydream, tie their shoes, or adjust a strap. Degas captured such moments in paintings like *Dance Class* and *Ballet Room in the Opera, Rue Le Peletier*. These artworks look almost like snapshots.

Did Degas also have the ballet students model for him?

In French, the little dancers were called "ballet rats," as they were always hungry and would eat anything they could get their hands on. Sometimes Degas would ask them to briefly hold still so he could make a quick sketch. But he only used one dancer for a model, Marie Van Goethem. She was the model for his famous bronze statue *Small Dancer Aged 14*.